*"At Milpitas Christian School we encourage the fine arts in all we do. That's why we are so pleased to offer The Marvegos® as an afterschool program. We believe art helps create well-rounded students. Rita and her staff do a great job as they work individually with each student at their level and help them find the artist within."*

*– Karen Lovejoy, Registrar/Office Manager, Milpitas Christian School*
*San Jose, CA*

*"I am proud to have The Marvegos® art program in our school. Their teachers teach the artistic process to our children. They discuss elements of art and the tools, which can be used to produce different effects the child may want. Their process promotes creativity and allows the child's imagination to freely express itself."*

*– Lois Evans, Director, Milpitas Montessori School*
*Milpitas, CA*

*"Having The Marvegos® at our school provided our students with an exceptionally fun and supportive art experience. The variety of art media offered allowed the students to develop their skills as well as to stretch their imaginations. Student projects were always wonderfully displayed which led to the students feeling a great deal of pride for their artistic accomplishments."*

*– Sheryl Thomas, Vice Principal, Sierra School*
*Santa Clara, CA*

# Teaching ART to Children

## THE Marvegos® Way

Rita Young with Joan Hong

The Marvegos® Fine Art School
www.marvegos.com

This book is dedicated to
my quiet guides,

Gong Lut Young
Gee Kwock
Morris & Merle Green

# ACKNOWLEDGEMENTS

I want to thank all the people who are the stories behind my story. Through it all is my husband and soulmate Rex, who encouraged me to follow my interests to build my dream. He truly understands how to use creativity in every aspect of his life. To my beautiful and creative children, Peter and Alexis, who were the genesis of The Marvegos® and are my contributions of hope for a better world. To my father, David Young, for a youthful and positive outlook, and for artistic genes. To my mother, Pearl, who set high standards for leading a good life.

I also want to thank the very special people in my life who influenced the shape of The Marvegos®: my dear friend, Joan Hong, for giving me six years of space and encouragement to write this book; her husband, Roger Day, for good food, good wine, and for good times; and their ever creative daughter Liz. I thank my sister, Lana Young, who told my parents when I asked to study art, "Not everyone can draw, you should let Rita study art"; Avedano Ramos for his artmanship in constructing our studios and for sharing his SF views; and Steve Suzuki for creating edible art for our exhibits and years of indefatigable help. I want to let the people who kept The Marvegos® going in the early years know that their support will always be valued: Mary Luke, who demonstrates that the creative spirit is stronger than opinions; Nisha Advani, who reminds me that The Marvegos® is a unique place for children; and Roshan Bedi, Asha Bhoopalam, AiLing Chen, Winnie Chin, Joan Christensen, Olga Dorf, Stella Dressler, Valerie Eilerts, Mary Fields, Joyce Lin, and Deviyani Patel. Sujata Acharya, Lan Ali-Adeeb, Julie Arment, Lois Brouillette, Lana Chen, Ivonne

Chin, Laura Darnell, Becky Ho, Mimi Hu, Susie Kim, Robin Koenig, Anmari Koltchev, Ling Li, Krista Lin, YiWen Lin, Tomasa Macapinlac, Amy Oh, Liz Rothschild, John Selleck, Cyndy Shiba, Selin Turan, Vicki Umeda, Francine and Richard Webber, Ellen Wong, Sheree Yee, Judy Yen and Leslie Zane helped us grow. My deepest gratitude to you all. I thank, too, Jim and Winnie Welton of Half Moon Bay and Dennis and Eunice Lo of Foster City for traveling the greatest distance every week for many years to our studios.

I also want to thank all the instructors, past and present of The Marvegos®, with special thanks to Christine Endo Hirabayashi, Melissa Satterberg Gainer, Masako Miki, and Irene 'Iamori' Kwock for hanging in there through thick and thin. A special thank you to Summer Thornton, who breathed organization into our studios and worked hard to make this book visually appealing.

Thank you to all the people who made suggestions to create a more readable book, in particular, the master editor Mikki Bazurto-Greene, whom I serendipitously chose to edit my book and am so glad I did; the author of *What it Takes* and teen motivator James Richards; the "take the time to enjoy the finish" Michael and Bernice McGreevy; the insightful Jay Lim; the "read it out loud" Doris Young; and the "I got the first read" Maureen Medeiros.

My deepest appreciation to all the students who made The Marvegos® shine year after year. Some students I would like to mention by name: Emily A., The Arenas, The Arments, Ankita A., Aliza and Shira A., Suneil A., Kelsey and Cole B., Kathryn and Patrick B., Cassie B., Sarah B., Akhila B., Emma B., Dolan C., Inga C., Lauren C., The Chamberses, Isaac and Danny C., Ivy and Sophie C., Alice and Eric C., Sabrina C., The Dapkuses, Mara D., Steven D., Sonia D., Megan D., Allison and Sophia D., Janelle and Julie E., Elan F., John F., Alexa and Kalen F., Monika and Sahil F., Maggie G., Jasmine

G., Stephanie and Gloria G., Lena and Kira G., Arshan H., Katrina H., Sean H., Delphine H., Kristin H., Stephanie and Christine H., Emma H., Riya J., Deepti K., Sangmin and Julian K., Jaclyn and Kurt K., Melissa K., Minwoo K., Christina L., Sammy L., The Lees, Jeeyoon L., Dylan L., Jessica L., Kelly L., Chester L., Alex L., Tiffany L., Rachael L., Frederick and Roderick L., Emily L., Emma L., Jeffrey L., Sierra and Kiana L., April L., Johanne M., Samantha M., Katie M., Parker M., Emily and Evelyn M., Sarah M., Raka M., Anumita and Anupriya N., Maya and Amit N., Alicia N., Rohan and Sopan N., Nikhil and Pooja N., Nora N., Holly N., Aydin N., Lynne and Manna O., Charin P., Sharon and Daniel P., Julia P., Ashley P., Mariko P., Andrea P., Ishika P., Sebastian P., Teddy and Grace R., Christina R., Audrey R., Alexa and Liana R., The Rhees, Makoa R., Kirstin R., Cassie R., Audrey S., Sawyeh S., Alexis and Jessica S., Kaitlyn S., Samantha S., Rishabh and Rijul S., Sarah S., Bowen S., Aashika and Ritika S., Cauveri and Vrinda S., Boris and Jocelyn T., Andrea and Sarah T., Vanessa T., Alisha and Varun T., Lauren and Sarah T., Katie T., Kaan T., Isabel T., Abby V., Arianna and Luke V.S., April W., Deven W., Alexandra W., Michael and Megan W., Anneke and Christiaan W., Melody Y., William Y., Cosette Y., Annika Z. and the "salsa" girls- you know who you are.

I also want to remember those who embodied the spirit of The Marvegos® way, but who have passed away. They will not be forgotten: Louise Hong, Mr. and Mrs. Oy Hong, Paula and Clive Greene, and Pat Fields.

# TABLE OF CONTENTS

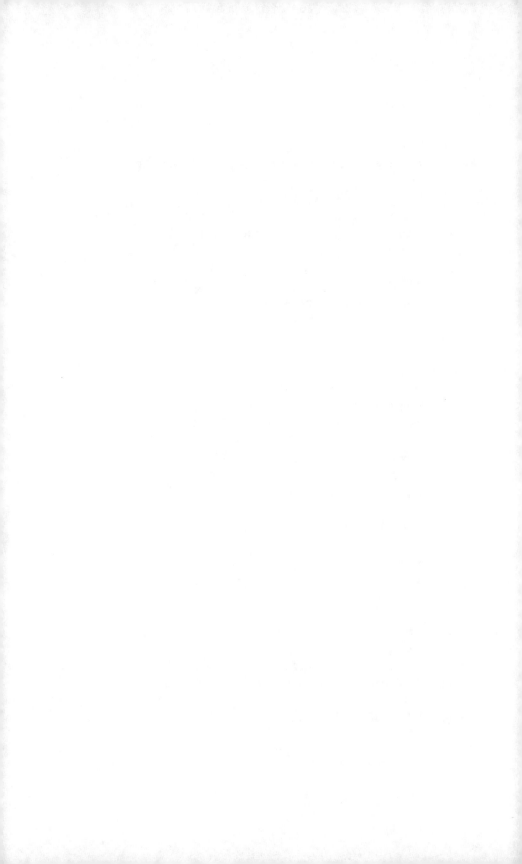

# INTRODUCTION

It's not easy being a parent who cares about their child's creativity, self-acceptance and self-confidence. Trying to figure out the right time, the right words, the right program and the right environment to nurture your child's development while juggling work, home and carpools is daunting. The Marvegos® Fine Art School (The Marvegos®) has an answer for parents with children who are visual learners, who want to draw or paint better or who are looking for something new to try.

The Marvegos® offers an approach to teaching art that rouses creativity to nurture self-development and self-confidence. Every facet of teaching art from project introduction to construction to timing and coaching the creative process offers a chance to nurture self-development and self-confidence.

The Marvegos® approach to teaching art begins with the notion that everyone is creative, and can be afraid of it or learn to use it with confidence. Creativity is making new connections that solve problems in art, science, math and everyday life. Creativity is inspired. It's exercised. It cannot be taught. The Marvegos® believes that entrusting children with making creative choices builds their confidence in their own creative abilities, and that exercising creativity engages the mind in ways other forms of learning do not.

Drawing, painting and other forms of art-making can be taught with or without using creativity. Copying is a teaching method that bypasses the exercise of creativity, since all creative decisions are already made. Decisions like where the trees are, how much sky is in the picture, and the color of the sky are creative decisions. Copying art teaches us how to follow instructions; the result is pre-determined. Copying art is not self-expression.

Self-expression is often rewarding and at times frustrating because the result is not predictable. When art-making is based on originality and self-expression, processes such as solving problems, making decisions, using resources, handling disappointments, taking risks, and accepting achievement are practiced. When students are given control of their artwork, even at 4½ years old, they learn to trust their own ability. Over time, this trust develops belief in oneself. The Marvegos® believes that this confidence in the self lays the foundation for taking risks and for adapting to change.

This book tells the how, what, when and why of teaching art to children, The Marvegos® way. Just as timing and materials are important to planning a great meal, the particular activities and art materials that are provided to a child at each stage of development are critical to a life-altering art program. The goal of The Marvegos® is to increase each child's self-confidence as they discover their own art-making style and to create a path for young artists towards self-directed art-making.

You will learn in this book how exercising creativity has structure and is not merely free art-making. Parents and art educators must let go of their own aesthetic preferences so that children may be entrusted with making their own artistic choices. Our children know their generation and their influences better than we do. Art-making allows them to tell their story based on their experiences and aesthetics. Art is constantly changing and each child's art speaks to this change. This book provides parents and art educators with a roadmap to follow in assisting students to be self-confident, self-directed and independent art-makers...to be and express who they are in their generation.

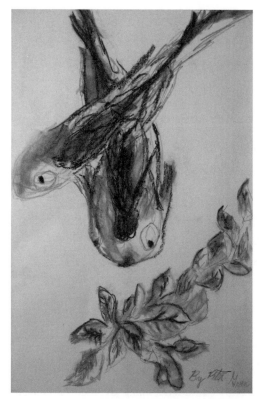

*By Peter G., age 8*

# CHAPTER ONE

## The Birth of The Marvegos®

# Teaching Art to Children

When my husband and I decided to have children, we made a list of the most valuable gifts we could pass on to them. Near the top of the list was learning how to make decisions. Initially, they made choices about what they wanted to wear or what soup they wanted for dinner. Eventually they made decisions about activities they wanted to pursue. The only guideline we set was that at least one activity had to be in the arts and another would be a team activity. For their art activity, our son always chose art while our daughter chose acting and art. By the time my son was 7, he had experienced teaching approaches that ranged from ones having little guidance to others that were more directed. I never did find the right combination of all the things I thought to be important in one setting. I wanted an art studio setting for my children and for other children in which:

- The creativity in their play, experimentation and exploration are part of art-making;
- Art can be made without concern for the mess that happens along the way;
- The choices students make are accepted and free from competition; and
- Children feel the instructors and students are on the same plane in terms of generating ideas.

Fortunately, I met another artist/parent who felt the same way. We set up an art studio almost overnight. In 1992, from humble beginnings, The Marvegos® Fine Art School emerged with the idea that creative expression is one of the most rewarding aspects of living a full life. The Marvegos® became a place where art starts with the self, and where children create freely

while confidence in their art-making develop. Building confidence is the key. Confidence builds appreciation of the self and provides a sturdy foundation for taking risks, for adapting to change, and for growing the self. This is the basis of the teaching method at The Marvegos®–the 'marvelous egos' (i.e., the self).

The Marvegos® approach to teaching art entrusts children with creative choices. Although this sounds matter-of-fact, the practice of copying among art teachers is alive and well. Many teachers assume that art should be taught. Many instructors believe that creative decisions need to be made for children and they use teaching methods that generate predictable results. These methods require little creative input from the child and include:

- Copying the artwork of another artist;
- The step-by-step approach; and
- Formula painting, which dictates how to produce art following someone else's plan.

Although each method has some merit as a starting point, these methods undermine the trust in one's own ability to create art.

A prime example of teaching rather than facilitating the process of art-making is copying. Copying someone else's art is technical, not creative. All the creative decisions are made by the original creator, including how much sky to include in the composition, where the trees will be, and what colors to use. There's a right and wrong to the copying process. Either it builds a strange, false confidence when done right, or it puts down self-confidence if done wrong.

# Teaching Art to Children

Copying is based on learning what marks and techniques the masters used. The theory is that by imitating those marks, the student's art-making improves. There may be a time when studying the marks of another artist is valuable. We believe that time is AFTER students develop their own style. To conclude that students are not able to make art until they learn how someone else makes art places the cart before the horse. Copying trains students to make marks like the artist they are asked to imitate. The process forces students to mask or adulterate marks natural to them in order to acquire another person's style. The struggle to find the mark that is their own after learning someone else's is a difficult one. Is it wise to work at being someone else before giving one's self a chance? Would you teach students how to write creatively by copying the words of someone else's story?

Children know the difference between decisions they make themselves and ones they do not. Summer C. and Remy, sisters, ages 11 and 9, started taking art classes at our Fremont studio during the summer. They accepted the responsibility for making their own creative decisions and worked confidently. When fall arrived, their mother, out of convenience, signed them up for an art class at a different school. The class dictated what the composition would be and how to render it. The outcome was flawless–good composition, good color and use. Not surprisingly, the experience left the girls feeling detached. The girls took their art home and "tossed it in the trash." In contrast, at The Marvegos®, the girls enjoyed using their own ideas. When all creative decisions are pre-determined, the discovery, the play and the challenge are taken away. The girls noticed the difference between a process that used their creative abilities and one that did not. Needless to say, they returned to our studio.

# Teaching Art to Children

Central to The Marvegos® approach is a studio setting that sets the tone for creativity to flourish. The five elements necessary to create such a studio are:

1. A creative and comfortable space;
2. Quality art materials and tools;
3. Small class size, i.e., a student-instructor ratio of 7:1;
4. Age appropriate projects, processes, and facilitation; and
5. Artists, as facilitators.

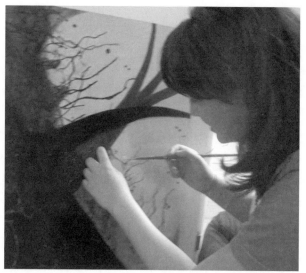

*Liz D., age 17*
*Liz created two new techniques while studying art at The Marvegos®.*

We will describe how to set up a studio that provides the freedom to create and how to plan projects for different age groups. Selecting art materials and hiring artists that can facilitate art-making with children will also be covered. Before we begin, I'd like to say a few words about children as natural artists.

## CHILDREN AS NATURAL ARTISTS

*"I'm a person, Mama."*

*Margarita M., age 3*

The skills necessary for art making are natural and familiar to children. Children's lives require coping with immense changes to make sense of the world. It is precisely these skills that are used in making art. This is the best time to help them identify the uniqueness in their own marks and develop their preferences by introducing the many options available to them in art-making.

In part, the marks and aesthetics that we are born with define who we are. They help to establish the point from which we operate and grow our creative selves. By 4½ years old, the difference from person to person in mark-making is as evident as our character and personality. Some children use big marks, others short and choppy, some are detail-oriented, and others make it bold and explosive.

Children's art often starts with a story. Their art-making process is a response to changes in their story as they happen and are not bound by an initial intent for their art. This minute-to-minute unfolding as they tell their

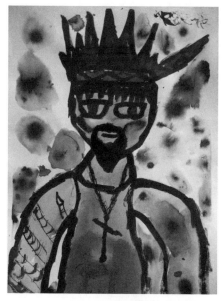

*By Ramie A., age 13*
*Students are encouraged to take risks.*

story captures creativity in motion. It is this process, inherent in children's play, that makes children's art so unique and interesting. For children, art truly is about the process and not the product. To harness this creative process into a coloring book or another product-oriented process stifles their creativity, degrades their abilities, and stresses product over process.

Ms. Evans, Director at a Montessori school where we provide an afterschool outreach program, once told me this story. As a young mother, she watched and listened as her precocious 3-year-old daughter, Megan (now in her 30s) made a Halloween drawing filled with flying ghosts, scary trees,

pumpkins, and haunted houses. The story delighted Ms. Evans as much as the drawing, which was fairly sophisticated for a 3-year-old. Ms. Evans was looking forward to hanging Megan's drawing. Megan then started covering her drawing in black paint. Ms. Evans, shocked to see the wonderful drawing begin to disappear under swipes of black paint, yet careful not to discourage the process, said, "Oh I like your drawing very much, can I have it, now." Megan, without looking up and continuing with the black paint said, "It's not done, it's night time." When Megan finished, she proudly handed the gift to her mother, who displays it to this day, remembering what's underneath the black and that with an artist, it's about the process.

*By Annie Z., age 10*
*Students draw ideas from the world.*

## EXERCISING CREATIVITY

Creativity comes naturally to most of us. Anyone who has discovered a new way to resolve a problem has exercised their creativity. Creativity is seeing something in a fresh, new way.

An example of exercising creativity occurred in the film *Apollo 13* in which a malfunction left the manned capsule without adequate air supply. The scientists on earth had to create an air filter out of things in the capsule in three hours in order for the astronauts to survive. Everything in the capsule that could be used from toilet paper tubes, wires, space shoes, shoelaces, tools, toothpaste, receptacles, etc., were thrown on a table and the scientists worked frantically to create an air filter. The scientific team was successful. And although it seems counter-intuitive, having too much of everything takes away the need to be creative. Ergo, a studio that turns children free to do anything they want wastes their time. A productive, creative environment requires structure.

Creativity is inspired. It is exercised. It cannot be taught. This book describes the setting, the approach, the staff, and the process that inspires and exercises creativity in the making of art. The processes described in the following chapters relate to specific age groups and include ways to handle the differences between age groups. Examples of projects for each program are used to illustrate the different approaches.

*Jason S., age 10*

# CHAPTER TWO

## A Program of Art For Children

# FORMING CLASSES

Classes at The Marvegos® Fine Art School are formed by age and not by level of ability. Classes build on children's interests rather than talent because interest is more important than talent when it comes to excelling at art-making. Students born with the gift to draw or paint and who have no interest in doing it will abandon art-making for pursuits that interest them more. Whereas children with less natural talent, but a joy and fervor for art-making, often excel at it, creating exciting and original art.

# CHOOSING NOT TO COMPETE

Another reason to group classes by age rather than level of ability is that the latter requires making a judgment about the art of a student. Judging creates competition, and competition skews the true goal of art-making. We do not approve of art competitions for children. If the competition is about who makes the better Michelangelo, that's measurable. If the competition is about how an artist handles watercolor, that's subjective. And yet, it is more measurable than a competition that lumps drawings and paintings, and representational (more realistic) and abstract works together, which is often the case with children's art competitions. When lumping all art together, including artists such as Michelangelo and Picasso, we ask, "Who is better? Is Michelangelo better or Picasso?" Even in the case of watercolor, with all things (e.g. composition, technique) equal, the winner is chosen subjectively. Ask any group of judges. If they're honest, they'll tell you that rarely is there consensus as to the absolute best work of art in this type of competition.

Competition is deadly in a process that uses art-making for discovering

the self. Children are adept at learning what their teachers want. They will do what it takes to get what they need, whether it's praise, a grade, or a prize. A completely different skill and a more valuable one is to figure out what they themselves want and how to build on it. The Marvegos® focuses on helping students discover who they are by allowing them to make decisions based on what they like. For example, decisions about color or what to draw or paint. Self-confidence is critical to healthy expression. Self-confidence is undermined in a competitive setting.

The Marvegos® approach provides children with technical knowledge to achieve what they want from a project and opens the door to creative choice. An example of technical knowledge in watercolor painting involves controlling the amount of water on the paper that affects the edge of the brush mark. The way to create a blurred edge or to create a crisp edge is technical and is not a creative choice. When to create the crisp edge or a blurred edge is a creative choice.

Onlookers are amazed that students in the same class, given the same direction and subject to work from, create artwork as different as their personalities. The variety comes from students responding to the subject in a myriad of ways. This experience is about taking risks because the outcome isn't guaranteed. Taking risks can result in exciting surprises as easily as it can result in creating problems. No matter the outcome, students learn that they have what it takes to complete their art and feel fulfilled with their accomplishment. If we are to free students to take risks and continue their self-development through art-making, comparisons and competition must be avoided.

# THREE PROGRAMS TOWARD
# SELF-DIRECTED ART-MAKING

Children are ready for different challenges at different ages. Although projects designed for younger age groups may be equally challenging and fun for older age groups, Marvegos® projects designed for older age groups are not suitable for younger age groups. Students may begin anytime with our program since it is based on age and not ability. Our three age-based art programs are:

1. Art Exploration for ages 4½ - 7
2. Fine Art Fundamentals for Ages 7-11
3. Advanced Exploration for Ages 11 and up.

Each program requires facilitating in a different way. The maximum number of students in a class is based on the time needed for facilitating. Art Exploration and Fine Art Fundamentals may have seven, and Advanced Exploration may have up to nine.

The next three chapters describe each of the art programs. In each chapter, we provide a:

- Description of the child;
- Description of the program and curriculum;
- Demonstration or how to introduce a project;
- Process for problem-solving or facilitating the art-making for each age group; and
- Sample project.

*Kiana M., age 4*

# CHAPTER THREE

ART EXPLORATION:
A PROGRAM FOR AGES 4½ - 7

*When Maaya draws, she always says, "I have to draw." It doesn't mean she is forced to draw by somebody, but only that she wants to express the ideas inside of her. It seems that she makes up stories in her mind -almost dreaming- all the time, and when her mind is filled up with stories she starts to draw. She draws for hours and hours. Her pictures always have a story. She draws humming, half-standing on the chair and moving her body like she's dancing. It is obvious to me that she is relaxed and having fun. I can't imagine Maaya without art-making. It would be like a flower without water."*

*Maaya at 5 years old, by Michiru A., Maaya's mother*

## THE CHILD: NATURAL EXPLORER
## AND NATURALLY ABSTRACT

Watch a child play. You'll notice their play is often a form of 'pretend'. Their pretend play extends to art-making as well, evolving on the page as their stories evolve. Like Maaya, much of art-making for this age group is about telling their stories. The process isn't an illustration process, where the story precedes the art-making, so much as the story is being created as the art-making is taking place.

My son, at age 5, enacted battles on his paper, crashing a brush filled with red paint on a drawing of boats and submarines complete with sound effects. The outcome is art, active and abstract. It is this abstraction that artists, including Picasso, worked to capture. It was Picasso who said upon viewing an exhibit of children's art, "When I was their age, I could draw like

Raphael, but it took me a lifetime to learn to draw like them." [1] Children's art is naturally abstract, and using art-making as self-expression is natural to them.

Children use art-making to connect with their experiences, interests and influences. Their influences or what inspires them is in their art, from animated characters and games to their family and friends, to emotional events, such as the tragic events of September 11, 2001. We chose to conduct class that day. Children came to art class with tele-'visions' of the falling towers. Many children, too young to understand the events, drew towers, falling towers and airplanes.

On the other hand, older children were affected more deeply and most talked about it but didn't consciously allow it into their art. Most of our teenage students were more pensive that day and their brush marks reflected a slower, more deliberate control, taking more time to make decisions about color and what to do next. We believe a surreal numbness set in as a reaction to the shock and the uncertainty of the events. We, as individuals or as part of a group, are affected by changes to our world. So, too, do subjects and processes in art-making change as our world changes. The Marvegos® approach bows to change and works to keep self-expression alive by giving students the time and space to be themselves.

## THE PROGRAM:
## PAINTING THE TREES PURPLE IS OKAY

Children are ready for the Art Exploration program when they begin to draw, making more than circles. The drawing may be as simple as stick

---

1 IngoF. Walther, 'Picasso" Benedikt Taschen Verlag GHmbH, 1999, Kohn, ISBN 382286371-8

figures, a wheel-and-spoke sun, or lollipop trees. Coloring within lines is not necessary or necessarily desirable. Readiness also includes the ability to cut with scissors. Although only a few projects require the use of scissors, strength in the base of the thumb and fingers that controls scissors is useful for other art-making activities.

The Art Exploration program:
1. Provides projects that exercise creativity. Making choices about colors, solving problems such as colors running into one another, and meeting challenges of filling a page are all part of exercising creativity;
2. Builds vocabulary used in fine art and an understanding of the concepts and elements used in art-making;
3. Makes art FUN by providing innovative projects and varying the art-making processes from session to session and year to year.

The imagination of the 4½ - 7-year-old is magical. Their imagination sparks at the slightest challenge to see things differently. They love to have fun and can be as silly as instructors allow them to be. Purple trees against an orange sky, flying grandmothers, stars and suns in the same sky, anything is possible. Mistakes turn into green rain or eyes of a make-believe monster. They are fearless art-makers when they know there are no limits.

The Marvegos® approach lets children make art on their own terms. For this age group, the abstractness of their mark making, their story, purple trees,

*The play of 5-year-old Molly L. extends to her art-making.*

and whatever they want to draw are allowed even if it opposes the planned project. A still life with flowers and birds may be used to generate ideas, but when children tap their own imaginations, they are generating their own ideas. Practice at generating ideas is precisely the goal of creative art-making.

Projects designed for children at The Marvegos® are age appropriate. Projects that develop observation skills for an 8-year-old, who is ready to see darks and lights, perspective, and tonal value, are not suitable for a 6-year-old. Developing observation skills in students younger than age 7 might be noticing how flowers may face different directions. Children may still prefer to draw flowers that look back at them. The creative process is in part a selection process no matter what the age of the creator. Insisting that the child include examples shown in the demonstration as proof of understanding

the demonstration ignores the ability of children to select what they want to draw.

Art-making should be fun, and variety makes it so for the 4½ - 7-year-old group. Variety of media from pastels to acrylic paints and variety of processes from painting to sculpting adds surprise to art programs. Varying processes used in projects also makes learning the vocabulary used in art fun. For example, texture created with watercolor is a different process than texture created with modeling paste. Students never know what to expect. One day it's a messy project; another day it's a fun, clean drawing project. We love to hear parents tell us how their children count the days until the next art class or wake up excited that today is their art day at The Marvegos®. Even parents want to take the class. One parent once said, "I don't mind being grouped with the children".

In addition to providing projects that are fun and creative, procedures are taught to empower children, such as how to mix colors or how to care for art-making tools. It is common to see young children on their own initiative putting their pastels away or stepping up to the sink to wash their brushes at the Marvegos® studios. Students become familiar with the studio surroundings in this way and feel free to make the space their own.

Managing all this fun requires keeping class sizes to seven or fewer children. Larger classes are accommodated by adding another instructor to assist with set up and facilitating.

*By Sarisha K., age 6*
*Young students tell stories with their artwork.*

## THE DEMONSTRATION

Since the Art Exploration program is one hour long, demonstrations help to focus the group on a particular project. A typical demonstration describes the materials, the process, and tools, and shows options for using the materials and tools. Only a little time is spent on this because learning about materials through play is natural for the 4½ - 7-year-old. More time is spent on sharing ideas stimulated by the project, still life reference or subject. The exchange between students is fun, often amusing and educational. These young minds show us how the world is changing.

Art Exploration students can understand the difference between shape, which is flat, and form, which looks more 3-dimensional, but it is very difficult

for them to use form in their work. Thus, it's inappropriate to focus on form at this time in their creative development. Instead, observation should focus on simple concepts such as the direction the head is pointing, or the number of legs that they see versus what they know to be true. Students begin to build observation skills in this way.

At age 4½, some children are conscious of the art school setting and are afraid of not measuring up. They believe only artists attend art school. Once the demonstration is over, they may need some assurance from their instructor that the only right answer is within each student before they will begin working. These children's fears are allayed when they realize that we want them to take charge of their artwork. When the fear disappears, the play and risk-taking begin.

Sometimes "I can't" is really "I don't know where to begin." Responding with, "So, what's your favorite color?" is a question that poses a creative decision most children feel they can make. All it takes is making their first creative decision to free most children to make others.

Karen W. was 5 years old and came with her parents for two years while her older sister, Rachel, was dropped off to art class. Then, she started art classes herself. Karen was outgoing and cheerful and the relationship with her sister was not a competitive one. When Karen started taking art classes at The Marvegos®, it was unexpected to see her sit defiantly upright, fold her arms in front of herself after the demonstration and with a pout and a harrumph say, "I can't do it!" Asking "What's your favorite color?" didn't work.

To engage Karen in art-making, we thoughtfully went over the various options out loud. "Hmm, I don't know where you should begin. Let's see, Ashley started with drawing the head and Kristin started with drawing the

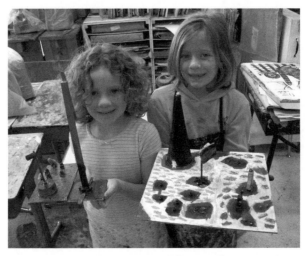

*Choices students make are as different as their personalities.*

body. You could start here on your page or here. I don't know where the best place could be on this huge sheet of paper. Should we start with the paper this way (horizontal or landscape orientation) or this way (vertical or portrait orientation)?" Karen makes her first creative decision by orienting her paper horizontally. The instructor supports her decision with, "That's a good start." "Now, what should be the most important part of your picture? You could make the tree the most important part." Offering a less desirable idea puts in motion a student's trust in their own ideas. Soon Karen decides to make an animal the most important part of her art. One decision at a time empowered Karen to complete her artwork on her own. Satisfaction with her work gave Karen confidence to continue with art-making.

# FACILITATING AND PROBLEM-SOLVING
## WITH AGES 4½ - 7

Facilitating the art-making for this group involves encouragement, praise, and an 'all's well' attitude. Students are encouraged to elaborate on their stories, adding and changing their art as the action unfolds. Most importantly, students have license to solve their creative problems, even if instructors have other ideas.

Problem-solving came alive for 5-year-old Nishad S. After the instructor's demonstration, students in the class modeled dogs out of clay. As I made my rounds with each student to see if there were questions or concerns, Nishad noted, "The head (on his clay dog) is too low." I said, "Hmm, I wonder how the head could be made higher." Nishad thought for a minute and began pounding his fist into the body of his dog. In seconds, the dog's head, unchanged, was higher than the body. The dog looked as though it was ready to lie down.

I would not have solved the problem as Nishad did. This illustrates how unnecessary it is for instructors to solve problems for students. Children, even at age 5, can solve problems. Trust them, sit back and enjoy the fun.

*By Alice K., age 6*
*A quiet "I did it!" is the sweet sound of success.*

## A SAMPLE PROJECT

Project:    Mixed media of flower(s) using marks from a variety of brushes to create texture

Materials:  Watercolor paints, 18" x 24" watercolor paper, variety of watercolor brushes, and black ink

Time:       Two days (1 hour per day)

# Teaching Art to Children

DAY 1: Introduce different types of watercolor brushes. On a piece of 18x24 watercolor paper, talk about the variety of marks that can be made with a single brush. Show how marks on dry paper and wet paper look different and that by drying in between layers, texture can be created. Describe texture. Texture may be described as what something might feel like if you touched it. Students will create texture with watercolor paint and several different-shaped watercolor brushes. Dry the watercolor with a hair dryer. Students will then choose analogous colors, which are colors next to each other on the color wheel, and use the colors to paint a watercolor wash over their paper of marks.

DAY 2: Observe flowers that face in many directions. Describe how the stem changes as the flowers face different directions. Students have the creative choice of facing flowers in the same direction or varying the direction the flowers are facing. Create a garden of flowers using ink and different ink-applying tools such as pens, brushes and sticks. Demonstrations are full of ideas and are not confined to one plan for a project. This strategy allows children the freedom to express themselves in their own style. Dry the ink with a hair dryer. Follow with another watercolor wash to the background only and/or detail the flowers in more richly pigmented watercolor paints.

*By Holly C., age 7*

# CHAPTER FOUR

FINE ART FUNDAMENTALS:
A PROGRAM FOR AGES 7 - 11

# THE CHILD: REALISM AND BUILDING AWARENESS

The 7 - 11-year-old child is increasingly aware of his surroundings. These children are working to connect who they are to their world. While they retain their individual sense of who they are and what interests them, they are starting to make social connections that expand their awareness of the world around them.

Building one's awareness translates into the child wanting more realism in their artwork at this age. This desire allows the age 7 - 11-year-old child to take on the work of observing in detail. Learning to draw and paint is largely learning to observe. Reducing form to shapes, or forms to simpler forms is a popular and effective observation tool that breaks observation into workable steps. However, to preserve creative choice by the art-maker, this observation tool should not be applied with a step-by-step approach. An example of a step-by-step approach involves the instructor leading with "the head is round" and students follow by drawing the round head; the instructor then describes and demonstrates drawing the neck, "The neck is a cylinder. Now, everyone draw the neck," and so on. The step-by-step approach secures an outcome but shuts off creativity. Instead, time set aside for observation, as part of the demonstration of a project, builds understanding of what is seen and allows creative interpretation to follow.

The student's creativity at this age takes a bold step forward when he discovers his own style of making marks. The Marvegos® acknowledges this developmental step by encouraging each student to build on their own marks, small or large. Students will create more comfortably when they express themselves most naturally. As students explore and include color, texture,

composition and other elements of art, their style becomes more complex and unique.

## THE PROGRAM: SINGING A UNIQUE SONG ABOUT THE WORLD WE SHARE

The Fine Art Fundamentals program focuses on two areas to help students with their interest in representational or realistic drawing and painting. The first is a study of form and composition; the second is to build their knowledge of drawing, watercolor and acrylic painting media. Form, composition and familiarity with drawing, watercolor and acrylic painting media provides students age 7 - 11 with a foundation from which their unique style can emerge. The emphasis of this program is to encourage students to explore their natural mark-making, color and design choices as their observation skills improve. Development of individual style gives voice to each child to sing their unique song, loudly and clearly about their expanding world.

The Fine Art Fundamentals program:
1. Builds on a student's ability to see and use form in art-making without sacrificing individual mark-making to make something look realistic;
2. Promotes understanding of drawing, watercolor, acrylic painting and mixing of media; and
3. Develops an understanding of compositional elements used in art-making.

# Teaching Art to Children

Honing observation skills for art-making opens an artist's eyes to nature, light, color and texture. Art classes that involve observing nature and one's surroundings build awareness of details. Heightening awareness trains students to take in visual information and enriches their experiences.

After a few art classes, parents notice a difference. Students walk out of their front doors in the morning and see the world differently because they are visually more connected with what there is to see. A parent told me her child forced her to stop the car on the way to school because the clouds and colors in the sky were so beautiful, her child couldn't wait to draw it. Another parent bought a decorative statue of an animal into her home, and her children ran to get their sketchpads to draw it. When art-making becomes a part of a person's life, the eye and mind is constantly open to inspiration.

*By AJ L., age 7*
*"How many grays do you see?" is AJ's favorite quip.*

*Ishani D., age 9*
*Students create their own style by personally solving problems*

Awareness and eagerness to meet challenges describe the 7 - 11-year-old. Selling projects that exercise creativity to this age group is simple. Begin with the words, "The challenge is..." and most children will sit at attention waiting for the game to begin. Projects that exercise creativity should begin with a challenge because restrictions and boundaries stimulate creativity. If every possible material and tool is made available to students, the art that ensues is most often mundane. Whereas, by restricting a project to "You can only use gray," for example, students are challenged to explore options that are not obvious. Projects that are designed with some restrictions result in exciting and unexpected solutions and demonstrate the creative spirit within each of us.

The size of Fine Art Fundamental classes is limited to seven students, with

six being preferred. This size gives the instructor time to assist every student with handling problems and providing encouragement.

## THE DEMONSTRATION

The inspiration for art-making can come from many sources. In an art studio, music and words inspire creativity as well as visual sources. Visual sources of inspiration include still life objects, photographic references, and things from nature. The Marvegos® Fine Art School relies primarily on visual references because most students are inspired by what they see.

Each class begins with a demonstration that describes the project and the materials. A few moments are spent visually studying the subject(s). Students are then provided with technical knowledge of the materials. For an example, painting with watercolors involves controlling the amount of water on the paper, which affects the edge you can expect to get. The demonstration would include how to create a blurred edge or to create a crisp edge. When to create the crisp edge or a blurred edge is a creative choice and is left to the student.

## FACILITATING AND PROBLEM-SOLVING WITH AGES 7 - 11

Time is the most important element in facilitating art-making for this age group. After the demonstration, it's important to leave students alone to work through creative choices. Requiring quiet for the first 15 minutes after the demonstration is helpful to allow the creative process to take hold. Instructors or other students should hold comments until the art-maker feels the project is completed to their satisfaction.

*By Michiko Z., age 8*
*Observation skills are honed without losing self-expression.*

Instructors assess what is visually happening in the artwork. Next, instructors describe the visual assessment with a series of questions to help students identify any problems. If there are problems, the instructor's role is to allow the student time to solve the problem. If additional help is required, instructors review different choices with the student. Instructors should be prepared to offer at least three ideas.

I have a shirt that reads "There are no rules in art." However, if the artist wants something to happen in their artwork, such as to create depth, then there

are rules that can be applied. Depth can be created using texture, line, color, values, and/or perspective. The question is which rule to apply. The correct answer lies with the artist. When students understand the problem and the possible options, it rarely takes more than 5 minutes for a decision. Making a decision about the solution is challenging and requires taking risks. Students eventually discover that if the decision creates another problem, that problem can also be solved. So it is with art-making and living life.

"I don't know" is the most common response to "How would you solve that problem?" Most schools train students to think there is only one correct answer. In art-making, there is always more than one answer to a problem. It takes time for students to adapt to this difference. One of my favorite responses to "I don't know" is, "Why don't you give it some thought and tell me three ways to solve that problem?" Invariably, students come up with three. If you ask for four, they believe there must be four and will try to give you four solutions. Try it!

Our students build their confidence in art-making from solving problems. There's a joyful release as problems are resolved. We want our students to feel the joy of "I did it!" that comes with successful problem-solving.

## A SAMPLE PROJECT

With the Fine Art Fundamentals program, visual elements of form, value, tone, gesture, weight and texture are introduced as tools. Using form is a leap towards representational art-making and distinguishes projects designed for students of the Art Exploration program from projects designed for students of the Fine Art Fundamentals program.

A sample project is to paint a still life using watercolor paints. A medley of

objects are arranged on a table for students to select what they wish to include in their compositions. The project requires several layers of paint beginning with lighter washes and increasing the pigment with each layer. The final layer or detail layer has more highly pigmented paint and uses detail brushes.

In watercolor painting, sometimes the blurred edge is an accident. The accident is what we call a creative problem. To resolve the problem, students may decide to disguise it, create something entirely new with it, add to it or blot it out. It's fun to watch the reaction of different personalities when they create accidents. Some students quickly ask to start over at the first sign of an accident, while others hardly notice them. Students learn that creative problems are part of the art-making process, and their solution to the problems makes their art unique.

Most children between 7 and 11 years old are willing to work more than two hours on a project as long as they see progress. For this reason, projects for this age group are not time-limited and the artwork determines when the project is complete. Often, classes are made up of students who complete their work at different rates. Students who make large marks always finish before students who include many details. When this happens, instructors provide additional one- or two-day projects for students who are faster at completing their project. This allows all students to work at their own pace and to their satisfaction.

*Kyle U., age 14*

# CHAPTER FIVE

## ADVANCED EXPLORATION:
## A PROGRAM FOR AGES 11 AND UP

# THE STUDENT:
## GROWING MORE SELF-DIRECTED

When our advanced classes start up, the tempo of our studio changes. There's a quiet buzz of activity. Many of the students, who come from home rather than from school, walk in wearing the same set of 'art' clothes week after week. Their presence is one of belonging. Students start immediately on setting up. Their art is stored where they left it. They begin on their own and they know what they need to begin their work. Many have a favorite place to sit. Students are ready to take charge of their work and to take care of the studio as the first step towards self-directed art-making. They begin by setting goals and taking more risks in their quest for greater self-confidence.

## THE PROGRAM: LEARNING TO MAKE DECISIONS

The Advanced Exploration program develops self-directed art-makers who want to pursue their own ideas about the type of art they want to create. Three steps prepare students to accept the responsibility and challenge of a program that relies on their own motivation. The three steps are:

1. Increasing familiarization with the materials and studio space;
2. Learning to set goals and design projects that help them reach their goals; and
3. Learning what their resources are and how to use those resources to help with making decisions.

Students begin the Advanced Exploration program by learning what it means to be an advanced student. An advanced student is ready to make decisions about what they want to learn and are ready to manage their own projects. Instructors expect that with a few preliminary steps, their students, ages 11 and up, will be prepared to handle the responsibility of a self-directed program. Students happily step up to the plate. Familiarity with the studio, its organization and the materials available to them gives students the confidence and comfort of working freely in the studio.

A typical first day for any new student includes a general tour of the studio space. Since advanced students are responsible for setting up, cleaning up and storing their work, their studio tour also includes details of supply areas and storage areas. Students notice where paint is dispensed and stored, where additional supplies are located, where to find still life references and photo references, and the storage area for their artwork.

Students are warned that the first day is largely a lecture day. Knowing what supplies are available to them comes next. All the supplies in the studio are organized into one of three categories: media, support, or tool. Media include watercolor and acrylic paints, ink, watercolor crayon, oil and chalk pastels, pencils, graphite sticks, charcoal, conte crayon, and more. Supports are what media go on and includes a variety of acid-free papers, boards, and canvas. Tools include brushes, masking tape, erasers, scissors, cups, palettes and so on. Students are shown where the supplies are located and given steps to care for tools, such as brushes and palettes.

Next, students are given a goal sheet to complete. What is it that they want to learn from their art class. Declaring their goals clarifies for the instructor and the students the purpose of the time they spend together. The students

*By Sharon C., age 11*
*All artwork produced by students at The Marvegos® are original.*

are invested in the program because they are motivated by goals they set for themselves. These students want to make their own decisions. When parents or teachers set the goals for these students, it's no surprise they lack motivation and a sense of direction.

Goals are defined broadly to allow creativity to evolve naturally. For example, a goal to explore a particular process can be reached even when exploration leads to changes in the process. A goal to learn about color in composition allows exploration to move in many directions without losing sight of the goal. However, a goal such as painting portraits of each family member in a particular style is inflexible to new ideas, inhibits exploration, and is, therefore, harder to attain. In art-making, responses to accidents and

unexpected surprises can result in extraordinary art, which may be missed if narrow goals are set. Yet, reaching goals is important to feeling successful and accomplished. Broadly defined goals allow us to reach our goals without fencing in our creative spirit.

When students decide on the goals for their art class, they begin designing projects to meet those goals. Instructors facilitate by reviewing the project design, media and tool selection to further ensure they are aligned with the goal. Developing new techniques and processes are encouraged, and the exploratory aspects of this program make this possible. Students discover the versatility and limitations of materials. This discovery often leads students to ideas for other art projects. When goals are stated broadly, students may consider new ideas and still move toward their goals.

Resources include, but are not limited to, nature, their experiences, photo references, the internet, their teacher, family and friends. As our children move from elementary school to middle school and onto high school, the views or opinions of their peers gain weight in decisions they make. Turning to peers for support reflects our children's growing independence. Peers offer a valuable perspective of common experiences and ideas unlike those of parents, teachers or others of a different generation. How old were you when you first thought your parents were behind the times? Ideas from others with similar experiences broaden one's viewpoint. However, the value of any input is compromised if the source becomes a crutch to making one's own decisions. Practice using resources and evaluating options for oneself to help make decisions gives us confidence to make more decisions and become independent thinkers.

# Teaching Art to Children

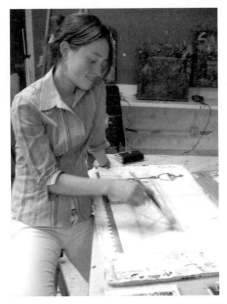

*Jasmine B., age 17*
*Work can be fun when you set the goal.*

A studio that gives creative choice free rein works better when there are rules. The roles of the instructor and student are established and repeated occasionally to maintain the creative milieu of the studio. Students are reminded that they are in charge of all creative decisions. The instructor's job is, to ensure that students understand the difference between creative choices and technical restrictions of the materials they choose to use. Instructors also act as facilitators to inspire taking risks, serve as sounding boards, help evaluate the completeness of works and exercise the creativity of their students by setting boundaries.

The class size of this group may be more than six students, but it depends

on the composition of the group. Groups with younger students, age 11 to 12, should be kept to six students per instructor. Classes of students who are more than 13 years old and/or who have grown up on The Marvegos® way function well even with groups of nine students per instructor.

## THE DEMONSTRATION

There isn't much need to demonstrate to Advanced Exploration students. Instead of demonstrations, brainstorming and dialog about solutions to a creative problem work best. Individual demonstrations are given as the need arises.

Students, without prior art-making training, are in the same situation as students whose past art training did not allow creative choice. These students typically feel more comfortable watching the instructor demonstrate a tool or technique and collaborating with their instructor in designing several projects before gaining the confidence to design a project of their own.

## FACILITATING AND PROBLEM-SOLVING WITH AGES 11 AND UP

Continue using questions with this group to promote problem-solving. Students age 11 and up are more sophisticated about getting someone else to make decisions for them. "I don't like it" is their way of asking someone to fix it. If the instructor or someone else fixes it, the student's initiative and self-confidence is immediately compromised. A possible response to "I don't like it" to keep students in charge of their own project is, "That means you're not finished. What do you want to work on fixing first?"

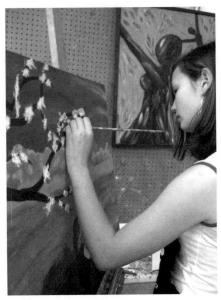

*Nina S., age 15*
*Setting goals is part of being an Advanced Student*

Students are encouraged to break the rules, but the outcome needs to resolve the problems created by breaking the rules. Through this process students become aware of the creative problems they tend to create and the solutions they tend to use to resolve their creative problems. Older students then begin exploring other ways of solving problems, thereby expanding their self-awareness.

Students progress through the Advanced Exploration program in a similar way. Usually they begin by struggling through every decision on the way to completing a project. It takes a speedy completion of just one project that is

created totally by the student and to their satisfaction to liberate them. An amazing flurry of successful projects soon follows. Not all students stay with the program long enough to reach this point, and each student reaches the point at different times. When it occurs, students feel the joy of taking the initiative and becoming a self-directed artist.

Liz D. is a good example. Liz started taking classes at The Marvegos® when she was 7 years old. In the Advanced Exploration class, she initially designed projects for herself that were best described as varied. After her first year in Advanced Exploration, Liz began a series of acrylic paintings. A great deal of Liz's planning time was spent on idle mode, thinking between layers about what to do next. During one of her idle moments, Liz started playing with frisket, also known as masking fluid, on a painting she had spent several days working on. This was fun for Liz and although there was some struggle to complete the painting, Liz decided to follow with another acrylic painting using the same process of applying frisket. This time the painting was completed beautifully and very quickly. The painting attracted the attention of other students and parents. Confident and still enjoying the process, Liz began a flurry of acrylic paintings using this process. She has moved on to work on developing other ideas for painting, but she still uses her frisket process to create original works for friends and family.

While developing new ideas for painting, students can expect some struggles, then plateaus. Often back-sliding precedes a leap in growth– all part of the process of making art and living life. Joyfully and not surprisingly, Liz enjoyed the creative process. Why? We believe it is because the goals reflect her interests.

# A SAMPLE PROJECT

An example of a study developed for students of Advanced Exploration is to find a process they enjoy and to create a series of five works that show exploration of the process.

While students in this program design their own projects, instructors often add a challenge to the student's project design to help a student move closer toward their goal. For example, if a student's goal is to explore color, instructors might suggest that the student use colors they wouldn't normally use. Challenges create problems that students solve in unexpected ways, often leading to exciting results.

During the course of a project, and at the end, instructors confer with students about evaluating the outcome of their work, what they learned from the process, and their satisfaction with the project design in terms of meeting their goals. Frequently this evaluation process generates ideas for other projects.

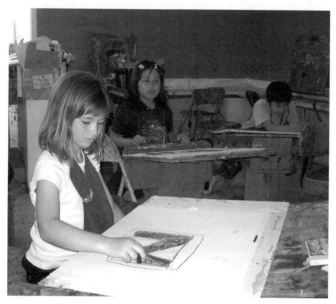

*Melanie, Gloria, and Patrick working at The Marvegos® studio*

# CHAPTER SIX

## THE SETTING: A CREATIVE SPACE TO BE YOU

## PHYSICAL REQUIREMENTS OF A CREATIVE SPACE

An art-making place for children needs to feel like it's okay to spill things. Safety is foremost followed by a place that puts value in the experience children have over the things that are in the space. Carpets are out because they demand attention at the slightest spill. Tables, meticulously organized, screaming order are not fun. Everything in a studio for a child should look like it's meant for use.

The Marvegos® studios have floors constructed from sheets of plywood, painted white, mopped regularly and repainted once a year. Each studio also has four different working surfaces to serve children of varying ages and the needs of various art materials. A low table is the perfect surface for younger students, whether they're standing and moving to music as they work on a messy music-inspired project or sitting creating parts for a collage project. Wooden studio benches with easels are set up for Fine Art Fundamentals students, ages 7 - 11, who are busy exercising their observation skills by circling around a still life study. For the Advanced Exploration students, studios are equipped with six-foot long table(s) with stools to provide working surfaces for a full gamut of creations. Pegboards along walls support wall easels for painters. Projects determine which working surface is best and students move freely from one to another as they need.

Running water is a must in any art studio, but a studio for children needs a sink that children can reach. Another must is storage for supplies. We have wood, wood tools, plaster, tools for plaster, metal tools and clay and clay tools and that's just for sculpting. We have four different printmaking processes, each with their own set of supplies. There are ink, watercolor paints, acrylic

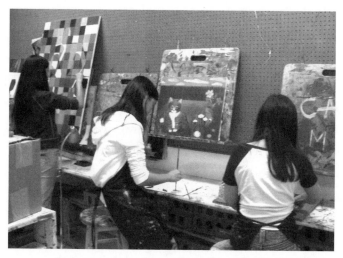

*Students choose working surfaces that are best for their project.*

paints, and pastels. There are palettes, tracing paper, brushes and cups. Oh! Don't forget still life references, what would we do without the beautiful colored jars and bottles, or the seashells and little bird models. Sounds fun, but to organize it, the secret is to have a place for everything and everything in its place. We like our supplies on carts with wheels to make reconfiguring the layout of the studio easier, but stationary shelves for storing supplies work as well.

Students learn about the studio and where things are placed. The feeling that the studio belongs to them and that they are free to get what they need is important. Establishing a comfortable space connects students with a place that frees them to create.

# Teaching Art to Children

Creative settings are important but they have no value if students are not allowed the time to work through the creative process. The creative process requires both time and space, regardless of the age of the creator. The process includes making decisions about color, the overall look, the story, and having moments of 'Oh! I like this but now I need to fix that!' Solving problems is part of the joy of making art and children experience it the same as adults experience it. When the creative process is interrupted by someone who offers, "Oh! Use this blue" or "Why don't you add a leaf here," it breaks the momentum of creating. The creator can't help but stop to evaluate what the other person has to offer and may even begin to doubt their own choices before their own creative process is allowed to work itself out. At The Marvegos®, students learn to respect the problem-solving abilities of fellow students.

## QUALITY OF ART MATERIALS AND TOOLS

My children grew up with fine art-making materials, including acrylic and watercolor paints, a variety of paper, and drawing media. They never had a coloring book because a blank sheet of paper allows children to express more. Ask a child with a completed coloring page, to tell you about the page. Ask the same of a child about their drawing. The artwork that my children created at home was so beautiful to me. There was very little in art programs at our local public school or community centers that we felt topped what could be created by simply providing the freedom and materials to create. Although their art experiences from elementary school and other art programs were relevant, they produced largely refrigerator art – art created by a pattern, cut and glued from construction paper, poster paint, and sometimes watercolors on drawing

or printer paper. These hung for a day or two on the refrigerator and then were discreetly buried in the trash.

In our household, the difference between the art that got framed and the art that became refrigerator art was the originality of the work and the use of quality materials. We proudly display my children's art in our home because they are aesthetically pleasing, embodies creative choices, and marks a particular time in their lives. It's like seeing their tiny handprints on the clay plaque they made in kindergarten. And because we know the paints are colorfast and the paper archival, framing and displaying it is a worthwhile expense.

Entrusting children to make creative decisions is to trust them with higher-quality materials, the best you can possibly afford. You'll want to keep their masterpieces forever, like their clay handprints. Philosophically, The Marvegos® is in line with the Montessori approach to empowering children. When they're young, teach them how to set up a palette of paint, care for their brushes, use the right amount of paint, and mix colors to increase their palette of colors. Allow children to learn at their own pace and make their own mistakes.

Although the process is more important at The Marvegos® than the product, self-confidence is nurtured when students like what they create. The outcome of a project is often improved with better quality materials. Using papers that are made specifically for drawing, watercolor, or charcoal and pastels make a difference in the outcome of the project. There was a quiet 4½-year-old who painted a rainbow with watercolor paints. When the colors started to blend, her delight was so sudden, it startled me. "This is the most beautiful rainbow I ever made," she screamed. The paper, the colors, the quality of paint, and

the brushes all made a difference. Providing children with quality materials demonstrates confidence in the child as art-maker. Confidence in a child begets self-confidence in the child and this justifies using quality materials.

We shop competitively for materials to keep our classes affordable. Watercolor paints are well-pigmented and translucent while acrylic paints are well-pigmented and opaque. This requires using more than one brand of paint. Some less expensive brands have decent greens but have reds or blues that don't mix well with other colors. Pthalo green can be mixed with yellows and blues to create a huge range of greens. It's important to have a core of colors that maximizes the range of colors that can be mixed from them, so students have what they need to mix any color they have the imagination to create.

Students learn that art materials are not precious but should not be wasted. As students grow and begin to purchase art materials, they may become conscious of the cost and feel reluctant to waste. Reluctance to waste is good, reluctance to use is not. At The Marvegos®, students learn the importance of setting up a full palette in a quantity necessary for the time they are in the studio. What is thrown out at the end of a session is a necessary part of art-making, not a waste of precious materials.

Of course, good tools are important too. The camel hair brushes in paint sets created for children are often constructed poorly. Synthetic brushes are a good alternative. Not as expensive as some natural hair brushes, synthetic brushes offer an excellent selection of sizes and types that provide interesting marks to explore. The Marvegos® studios are equipped with three types of brushes: watercolor, acrylic painting and craft brushes. Replacing brushes can be costly, so using them properly is vital. Rarely should watercolor brushes

need replacement while acrylic painting brushes and craft brushes are replaced more often.

As a parent and art educator, care in selecting materials that are non-toxic and tools that are safe for children to use are important. Printmaking and sculpting are fun but the processes and materials need to be adapted for safe use by children. Block printing and silkscreen (serigraphy) printing are two printmaking processes with supplies on the market that are safe for children. The Marvegos® has also created monoprint processes and an intaglio process that is safe for children. Additive sculpture projects are safer than subtractive methods of sculpture making because tools for additive sculpting are few and safe.

Safety makes art studios a comfortable place for discovery. Many colors and interesting materials with a multitude of ways to use them add to the joy and excitement of art-making in a studio for children. This type of space gives all the different personalities and developing egos a way to learn about who they are through art-making. The discovery that happens develops an appreciation of their individual marks and aesthetic choices.

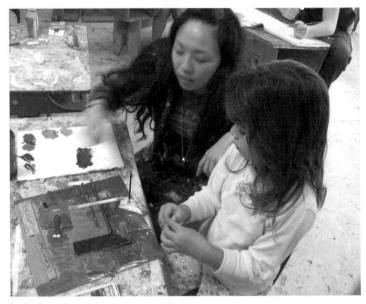

*Instructor Liana H. respects the decisions students like Clara C., age 6 make.*

# CHAPTER SEVEN

## THE ROLE OF INSTRUCTOR AT
## THE MARVEGOS®

The Marvegos® instructors are degreed fine artists that have been trained on The Marvegos® method of teaching art to children. As an artist-teacher, the impulse to offer a solution to a creative problem is tempting. The creative urge and aesthetic eye of an artist are hard to quiet. Yet by making creative choices for children, teachers send subliminal messages that take away the self-expression aspects of art-making and cramp the exercise of creativity. One message is that the student is not able to solve their own creative problems; and, secondly, there's a right and wrong to art-making.

Mina A. is seven. Every Saturday for the past three years, she has attended art class at The Marvegos® and then goes next door to the Saratoga School of Dance. Saturday is Mina's favorite day of the week. Mina's mom tells how after art and dance class, Mina is on top of the world. Everything from the way she stands, the way she walks, her voice, what she says, and her facial expressions spells self-confidence and happiness. She carries this self-confidence through the weekend and into Monday. When Mina is picked up from elementary school on Tuesday afternoon, mom notices a change. Mina's self-confidence is gone. She's not sure of herself and expresses to her mother, "I can't do it" and "I don't know how to do it." This cycle recurs every week throughout the school year. Something in Mina's experiences at school makes her feel powerless. Art and dance on Saturday renews her sense of self-worth, confidence and empowerment. In art, Mina enjoys learning, is great at making creative decisions, and uses her ability to solve problems. Mina's experience is not unusual and demonstrates how teachers can build or take away self-confidence in children.

## GROWING SELF-DIRECTED CHILDREN
## THROUGH ART-MAKING

At The Marvegos®, instructors become facilitators. It requires that instructors accept a child's ability to make creative decisions. The result is student empowerment and self-confidence. Problem-solving skills and the confidence to make creative decisions can last a lifetime. A solution offered by an instructor is limited to the one instance. Knowing when and how to help is the key to ensuring that the creative decisions are made by students. The secret to successful facilitating is leaving instructor's intervention until after the creative work of the student is complete. Older students, ages 7 and up, learn to step back from their art as a way to evaluate their own work. Instructors can offer a perspective of what the viewer sees to help students gain a fresh perspective.

In 2003, I attended a presentation featuring a retrospective of Marc Chagall's work at the San Francisco Museum of Modern Art. Bella Meyer, an art historian and granddaughter of Marc Chagall was the presenter. In her talk, she mentioned how Chagall often relied on his wife Bella to tell him when he was done. The Marvegos® instructors provide a fresh perspective and opportunities for students as Bella did for Chagall. Students recognize that it is their job to solve the problems created by the choices they make with their art and that the art needs to be resolved to their satisfaction. The process takes longer but the outcome is a sense of ownership and achievement.

People who have worked with me will tell you that there's one rule that I care more about than any other: "NEVER WORK ON ANOTHER ARTIST'S WORK." This very rule is why The Marvegos® was started and

*Taryn M, age 16*
*Adapting to change is part of art-making.*

applies to instructors, other students and parents. When teachers put finishing touches on the artwork of their students, they undermine the student's confidence.

When 4½-year-old students walk out of our studio with works of art that The Museum of Modern Art should exhibit, why take the creative decisions away from them? Providing a solution for children lowers the value of the creative experience for them.

Hannah U., now 8 years old, remembers drawing a tiger in another art class when she was four. When she finished, her teacher thought the tiger Hannah drew needed an ear. So her teacher added the ear to Hannah's drawing.

57

# Teaching Art to Children

Hannah now saw three ears on her tiger. Fortunately, it was obvious to Hannah that the teacher didn't know anything about tigers. If the teacher couldn't see the tiger's second ear, we at The Marvegos® suggest asking Hannah to describe her tiger and sharing with Hannah how difficult it was to see the second ear. You can trust Hannah will know how to fix it. It's been 4 years, half of her life, and Hannah still remembers how her art teacher worked on her art and put a third ear on a perfectly good tiger.

The Marvegos® instructors use questions to help identify creative problems. Samantha R., 7 years old, was drawing a cat. When she finished, it was unclear where the cat was. We asked her "Where's the cat's ear?" and "where's the other ear?" After a few more questions, we realized that Samantha had started with a small drawing in the middle of her page and as she drew her cat, her observation skills became keener and she saw more details. The parts of the cat that were drawn near the end of her process were larger than the parts of the cat she started with, reflecting all the nuances of the cat that she saw as her observation skills improved. The process was enlightening to both Samantha and us. To assume that instructors have the creative solution to this problem is ridiculous. The process allowed Samantha to exercise her seeing skills at her pace and had greater value to her as an artist than making the cat look like a cat.

Art-making is more fun and self-expressive for students when instructors facilitate, inspire and serve as a resource. Instructors who facilitate can broaden a student's knowledge of media, tools, or imagery that could help in designing or simplifying a design or process. Active listening skills are the most valuable source of inspiration to students. Students often only need someone to bounce ideas off of. If instructors remain interested and ask

questions that help students flesh out their ideas, students become self-directed and will constantly surprise you with creative work and amazing stories. The insight of young people and their natural art-making skills keep us all tuned in to new ways to marvel at the world.

## QUALITIES OF THE MARVEGOS® INSTRUCTORS

The qualities that are required of an art instructor at The Marvegos® includes the ability to communicate with children, an interest in what children have to say, appreciation of children's artwork, and having the strength of ego to allow the child's choices to stand. Instructors at The Marvegos® are artists with at least a bachelor's degree in fine art (studio) and must have a strong portfolio of work that demonstrates knowledge of composition, drawing and painting.

The Marvegos® depends on our instructors to play an active role in living the vision of the school. Our vision is that generating a creative environment enables every student and instructor to further self-development. Each studio continues to adapt to change as instructors change, but feels cohesive because The Marvegos® is built on teamwork and a common mission to empower creative choice within a safe and supportive art-making environment.

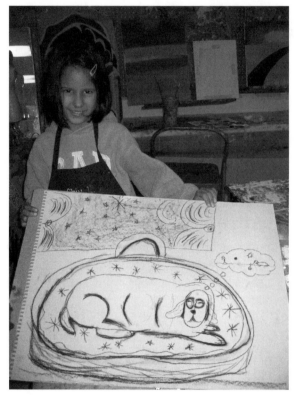

*Maya L., age 7*

# CHAPTER EIGHT

## A ROLE FOR PARENTS

# SUPPORTING YOUR CHILD'S CREATIVE LIFE

In earlier chapters, answers to the most frequently asked questions are covered, but there remains a perspective that we want to share with parents to support their child's creative life. Most parents who want their children to take art class feel it is important to balance their children's academic and physical experiences with an activity that is self-expressive and creative. Of course, some parents simply want their children to draw better or to overcome the frustration with school assignments that require drawing.

The creative process waxes and wanes. There's no magical age when a child's ability to see and use form happens or when the first conscious creative risk is taken by a child. Art-making, like learning anything new, appears to start with an immediate growth spurt at the beginning of lessons and often tapers off or even gets worse before the next leap of growth. Be patient and enjoy the process of growth along with your child. As in life, if the time isn't right, no amount of work, worry or pressing makes something happen sooner than it is ready to happen.

Determining the competence level or grading a child's work to advance into higher levels of art making is a competitive issue and does not belong in an environment where the creativity of a 4½-year-old is as highly regarded as the creativity of a 17-year-old. Starting the process of honing observation skills should not be rushed. When observation becomes the focus of art-making for students too young to appreciate it, they lose the most basic reason for creating art, which is self-expression.

Art-making is different from learning music or dance. In dance and music, students continue along a path of mastering their instrument or steps

and timing in dance, step-by-step onto more advanced levels. Art-making, on the other hand, allows us to create beautiful works of art without first mastering other techniques. For example, you do not need to draw before you paint. The process of drawing and painting are different. You look at your subject differently when you draw than when you paint. The marks created by drawing tools and painting tools are different and can be used independently.

Although most students are observation-based artists, who respond and draw inspiration from visual imagery, some are not. I've worked with 4 students, in 15 years as an art educator, who were inspired by materials rather than visual sources. We call these students materials-based artists. My first experience with a materials-based artist was with a 6-year-old girl, who was working with charcoal. I watched her build up layers and layers of charcoal on her paper, rubbing areas in and adding more. It was fascinating because she worked filled with energy, then stopped to look for a minute and started up again. I turned away for a minute and when I returned to her, the beautiful layers had become a heavy mass of black and gray and her mouth was black with charcoal. Children who are materials-based artists don't know when to quit. They enjoy the tactile as well as visual qualities of materials and will play with them until there's nothing more to do than smear it all together. Materials-based students are provided with larger sheets of paper or several sheets of paper to complete their exploration fully.

Our Fine Art Fundamentals classes, for ages 7 - 11, focus on developing observation skills. Most students remain in Fine Art Fundamentals for 3 years and continue to benefit from the program. The materials-based artist, however, takes only one year of Fine Art Fundamentals and moves on to the Advanced Exploration program where they are able to design their own projects. The

reason is observation skills are not relevant to students who are materials-based.

Parents who stay for the demonstration of a project are reminded not to take the demonstrations literally or expect their child to do everything the instructor demonstrates. Demonstrations are not meant to be followed to the letter. Students know this. If students do exactly as they are told, they are copying. They are not learning anything about their own creative process and not enhancing their art with self-expression. They may thoroughly understand the demonstration and may not have an immediate need for all the information, choosing only what works at the moment. The unused information is not lost. It resurfaces when students are reminded by their classmates, during another demonstration, or when there is another opportunity to use it.

To further the art-making experience that students gain in art class, we encourage parents to take their children to art museums. Experience looking at different types of art builds awareness and develops one's aesthetics. It stimulates thinking about the function of art and artists in the natural order of life and helps students gain a sense of when a work is done. The ability to recognize when a work is done is important for students that are in a self-directed program even though it's sometimes difficult to know without the fresh perspective of another viewer. Some exercises that we recommend to children visiting art museums are to stand in front of a picture that they dislike and figure out why the museum decided it was worthy of exhibiting. Another exercise is to dissect the layers of a mixed media project to determine what was done first and the process that followed to create the final work of art.

There are as many developmental differences as there are personalities of children, but we sometimes forget when we look at our own children. Most

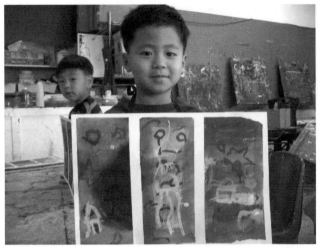

*Jiwoo S., age 6*
*Young art-makers are proud of work that is their own.*

children are able to shade and make their drawings look real by 8 years old. However, 8-year-olds who make big, simple, bold, and exciting marks or who have an innate sense of color use are equally worthy of appreciation.

Taking the time to appreciate the work of your children gives them the confidence to be who they are. Trust that even though you may not be able to recognize any of the objects on the page, there is a story your child is telling. Quick compliments like, "I like it" is better than comments like "What is this?", but specific comments such as "I love how you put these two colors together" or "I like how everything looks like it's in motion" or "There's so many interesting details to your art, tell me about it" show an appreciation of the actual work that went into the making of the art. In the next chapter we

discuss the importance of building an appreciation for art and self-development by exhibiting.

Finally, expectations by others get in the way of reflecting into oneself. Art-making is a process that can be introspective, allowing the artist to look within as they make sense of their world of experiences and interests. Art is continually being redefined and art forms continue to change as the experience of each new generation interprets their experiences. One of the greatest gifts you can give your child, therefore, is room to discover who they are in their time.

*Maaya A., with Founder, Rita Young*

# A GALLERY
# OF STUDENT WORK

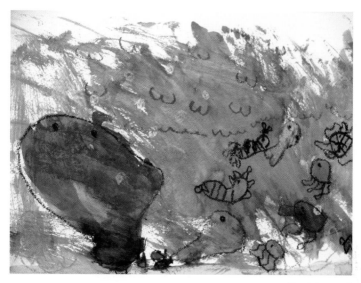

*Tanvi A., age 5*

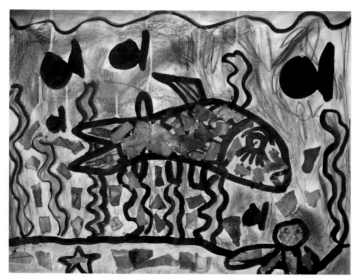

*Gloria L., age 6*

*Annie G., age 5*

*Jasmine B., age 6*

*Skyler L., age 7*

*Suf C., Age 7*

*Connie P., age 8*

*Naoka N., age 9*

*Jennifer L., age 9*

*Hannah B., age 7*

*Jenny L., age 9*

*Abby F., age 9*

*Melissa P., age 10*

*Alexis G., age 8*

*Rylan H., age 10*

*Sydney U., age 14*

*Hanaa A., age 11*

*Andrea L., age 14*

*Peter G., age 10*

*Janvi S., age 13*

*Allison W., age 13*

74

*Pamela H., age 14*

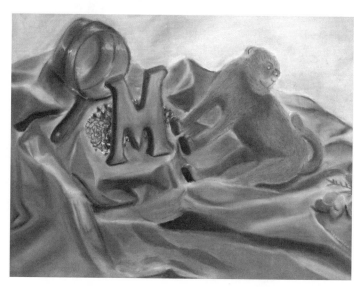

*Veronica T., age 12*

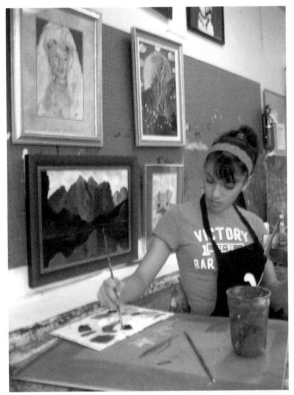

*Andrea W., age 15*
*Original works by Andrea are shown behind her.*

# CHAPTER NINE

## A LOOK AT THE RESULTS

Tony and Jackie N's parents sent them to The Marvegos® because they wanted their children to be able to do the drawing portion of their school assignments. We had no confidence that we could help them achieve this goal, since our focus is to help students develop their individual style. This means that if the student makes big powerful marks, then we encourage the use of those big powerful marks. We also didn't know whether Tony and Jackie's school teacher appreciated individual style. It was difficult, then, to know whether what they learned would work as acceptable art for school assignments.

After a couple of years with The Marvegos®, we were happy to hear Tony and Jackie's mother tell us that the class had an extraordinarily different effect on the children than she had anticipated. In this case, Tony and Jackie developed more self-confidence through the classes. This confidence in their ability as artists became evident. They volunteered to do the art portion of group projects and became known as artists to their schoolmates.

The success stories are many. Most of the stories go beyond art making. It is the development of autonomous young people who feel self-worth through the art-making process–that is the beauty of The Marvegos®.

## THE ART EXHIBIT

At the end of each school year, students who devote the year to studying fine art with The Marvegos® qualify to exhibit at our annual year-end student exhibits. Parents frame their children's art and the studio is converted into a gallery for one day.

# Teaching Art to Children

The exhibit is a priceless experience for the young artists. To make it memorable, the illusion of a gallery is created. The messy floors are painted white, everything is cleaned up, the benches are stored, along with all the supplies, and tables and dividers are positioned to display each piece of art. Students, who contribute art to the exhibit, come in during the day and have an opportunity to discuss on videotape the process of making their art. The person who interviews each artist asks them their name, age, and the name they gave their work of art. Some children feel a little discomfort in front of a camera, but they react with pride in their work and usually warm to the topic of talking about their own art, as the interviewer prompts them with more questions. Some of their comments reflect how much they derived from taking art lessons.

At the last art show, several students indicated that they identified and used their favorite colors in their artwork. One 7-year-old boy was particularly proud of using different shades of blue and green. A 12-year-old girl said she liked her sky. She made it yellow, because she just likes yellow. A 7-year-old girl was wearing colors similar to her painting, causing the interviewer to notice and comment. The girl mentioned each similar color, then said, "I'm my painting." A 13-year-old girl put her ideas about the many choices facing her as a teenager in her painting. A 6-year-old boy indignantly expressed concern that the interviewer did not recognize a fish trap coming down on a crab in his painting. Another girl included her sketchbook in the exhibit. She started sketching when she was six; the book contained over two years of her sketches, which she said she created every week. An 11-year-old boy mentioned how he put some coral in his picture of a fish in the sea and that the coral looked almost real. A 12-year-old girl especially liked the way she

*By Alexis G., age 19*
*Owning one's own choices develops a unique style.*

did her cat's eyes, because she kept working on it until it looked just the way she wanted it to look. One girl could not resist adding at the end of her presentation, "I love Marvegos®."

A reception is held with all the trimmings of a celebration, from chocolate covered strawberries and cookie treats to sushi and eggrolls. Our exhibits have become events. Each year collectors and artists, even those without children, visit us to see what the children are creating. Every year, we are approached with offers to buy the artwork, which we discourage selling. Young children's artwork marks a time in their lives that is unique and cannot be regained. These

offers to purchase the artwork add to the good feelings and pride that come from exhibiting. This is a joyful and rewarding experience for students. The idea that mom and dad took the time to frame their art to make it look special among all the other beautifully framed pieces demonstrates appreciation for the child to be who they are, not a copy of someone else.

## THE MAGIC

The self-discovery process blossoms into an appreciation of oneself when children feel their efforts are valued. Ellie started at The Marvegos® at age 6. She had a very strong desire to excel in art. Her mother was an avid fan of the arts including pottery, painting and photography. The family visited museums on the weekends. And, they displayed their children's artwork throughout their house, which added support to Ellie's passion. While the family was having a party, a guest who was an interior designer, noticed Ellie's art in the living room. "Wow! That painting is fantastic! Where did you get it? Who did this?" "I did it!" Ellie piped up beaming. A group of guests gathered around to proclaim their admiration for her work.

Remember, Ellie owns every mark and made every creative decision. If the teacher finishes or works on the child's art, compliments are not as satisfying to the child who knows the difference. Art will always be a part of children, like Ellie, because she has developed an artist's eye to appreciate what she sees and now have the confidence to continue creating.

During the day of the exhibit, visitors stream in to view the art. Most visitors know one of the children presenting. Moments like Ellie experienced happen throughout the day. Children who contributed artwork to the exhibit

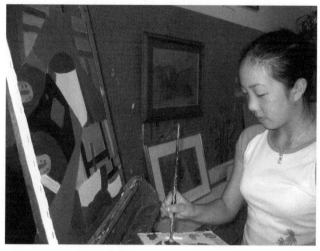

*Allison Y., age 14*
*Making decisions and using resources are practiced at The Marvegos®.*

wander around looking at other artwork, not paying much attention to their own. Then, a visitor who is a stranger to the child notices and comments on the specialness of the very art that child made without knowing that the child is present. This scenario happens with such regularity that we find it magical.

A parent who brought in artwork for this book mused about the piece. "I'll never forget when we exhibited this piece at The Marvegos® art exhibit. I was looking at some art on the other side of the partition, where Gloria's art was hanging. I overheard a couple talking about it, 'I wonder who Gloria is. I wonder if she wants to sell her art. This would look good in our living room.'" When the couple moved on, Gloria's mom walked quietly around the partition to look at her 6-year-old daughter's artwork with a renewed appreciation.

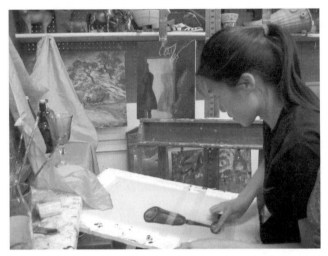

*Emily C., age 15*
*Awareness of things outside of the self is fostered through art-making.*

## THE RESULTS

In 2001, The Marvegos® studied how satisfied people were with the art training and whether the students' art-making skills and self-confidence were increasing. Rex S. Green, Ph.D., a research psychologist, designed a questionnaire to determine if the students of The Marvegos® were becoming better at making art, doing better in school, and getting along better with their peers, after attending classes at The Marvegos®. A brief review of the study is included in the Appendix, along with a copy of the questionnaire. The results indicated that the parents were very satisfied with the art lessons and thought that their children were gaining art-making skills and developing as individuals due to taking art lessons at The Marvegos®.

# Teaching Art to Children

The study findings were shared with The Marvegos® instructors. They were pleased with the results but not surprised. They also made positive comments about the quality of the art lessons, and relayed additional positive comments received from the parents.

There are a wide variety of teaching methods, each with a plan to improve the student's ability to make art in some way. Some plans are more thought out than others. The Marvegos® way uses art-making to guide children to build awareness of things outside of themselves and confidence and appreciation of their selves. Children's awareness of the world around them opens up as they search for ideas for their projects. Accomplishment turns to self-awareness and appreciation of self when the activity of art-making involves solving problems, making decisions, using resources, handling disappointments, taking risks and adapting to change– this is The Marvegos® way.

Projects that result from this teaching method are beautiful, unique and real because it begins with what is natural to children at particular times in their lives. Art-making at The Marvegos® uses the playful, magical, inventive, and creative agility that is the sparkle in every child. The sparkle that is unique to each child can glow strongly or be dimmed. The Marvegos® way leads to the glow.

# APPENDIX

In the spring of 2001, The Marvegos® studied how satisfied people were with the art training and how effective the lessons were in changing the students' behavior. A full report of this study was published in a research journal, Evaluation and Program Planning [Green, R. S. (2003). Assessing the productivity of human service programs. Evaluation and Program Planning, 26(1), 21-27].

One month before the annual art exhibit, 61 parents of The Marvegos® students volunteered to answer 21 questions (see following questionnaire), 16 of which were used to estimate the productivity of the art lessons. Service productivity equals the average change clients experience because of receiving services. The ages of the students ranged from four to 14. The questions addressed whether the students' involvement in art classes had caused them to improve their art-making skills (7 items) and/or develop as an individual person (7 items). The parents answered yes to 77 percent of the art-making skills questions and 50 percent of the individual development questions. Parents also were asked two questions about how satisfied they were with the services. Forty-eight of the 61 parents indicated they were maximally satisfied because they got everything they expected, as well as other things that were useful to their child.

The percentage service productivity scores ranged from 7 to 100 percent; the mean was 63.1 and the standard deviation was 26.8. The mode was 100 percent, reflecting a positive bias in the scores towards maximal change on the 14 items.

The reliability of the 14 items was .85, based on Cronbach's measure of internal consistency. The construct validity of service productivity was determined by formally scaling the 14 items and 61 students using multidimensional scaling. A 3-dimensional scaling of the profile similarity scores for each student yielded a goodness of fit to the model of .87, higher than .81 for the two-dimensional solution. The dimension loadings for all three dimensions were entered in a multiple regression analysis to predict the productivity scores. The multiple R was .992. The first dimension received the largest standardized beta weight, -.992, indicating that the percentage service productivity scores closely matched the loadings on the first dimension. The correlation of the productivity scores with level of satisfaction was .31, indicating moderate correspondence. Thus, construct validity was demonstrated by a high correlation between the two sets of service productivity scores measured in different ways, versus the low correlation with the satisfaction scores.

The satisfaction of the parents also was expressed by responses to the last question, "Other comments or suggestions?" They said: "We love the teachers! What a great program! My child loves her art class! All positive experiences!" Some parents also provided constructive suggestions for improving the art program, e.g., "It would be great if there were more written and oral feedback to parents." These results supported concluding that the art lessons provided by The Marvegos® were succeeding in meeting the students' needs and satisfying parents that their children were benefiting from this experience.

The methodology applied by Dr. Green to measure service productivity differed in several ways from the most commonly utilized experimental designs. His approach simplifies the study design and focuses on what changes occur in recipients of services because of service activities. Following this study, he published three more articles about other applications of this method. Evaluation projects throughout the San Francisco Bay Area now employ this approach, with over 50,000 youth being assessed each year. The Marvegos® is proud to be the first service organization to demonstrate the advantages of Dr. Green's approach.

THE Marvegos FINE ART SCHOOL

# Service Improvement Questionnaire

Please help us continue to improve our art program by taking a few minutes to fill out this form. Answer the two questions below first, then turn this form over and answer the questions on the back. Turn the form in to your child's instructor or to the Director, Rita Young. Thank you very much for taking the time to let us know how your child is doing.

Date: _____   Age of Your Child: _____

Considering everything you think happened to your child *as a result of* receiving our services,

1. Did your child get . . .                              (Circle only one answer)

      A. Everything you expected . . . . . . . . . . . . . . . . . . . . . . . . . . . . . . . . . . . . . . . . . . . . . 1

      B. Most of what you expected   . . . . . . . . . . . . . . . . . . . . . . . . . . . . . . . . . . . . . . . . 2

      C. Some of what you expected   . . . . . . . . . . . . . . . . . . . . . . . . . . . . . . . . . . . . . . . 3

      D. None of what you expected   . . . . . . . . . . . . . . . . . . . . . . . . . . . . . . . . . . . . . . . 4

2. In addition to what you expected, did your child get . . .        (Circle all that apply)

      A. Other things that were useful to him or her . . . . . . . . . . . . . . . . . . . . . . . . . . . . . 1

      B. Things that caused you or your child problems  . . . . . . . . . . . . . . . . . . . . . . . 2

      C. Things detrimental to your child, such as slower personal development,

           embarrassment, personal injury, or illness  . . . . . . . . . . . . . . . . . . . . . . . 3

**Please turn me over to answer the questions on the other side.**

88

Tell us more about how our art classes have affected your child. Please circle Yes (or No) for each item if it happened **as a result of** our services, then Yes if you expected it to happen. Be sure to circle either a Yes or No in both columns for every item.

|  |  | This happened | | I expected this | |
|---|---|---|---|---|---|
| 3. | Learn how to draw or paint better | Yes | No | Yes | No |
| 4. | Have some fun | Yes | No | Yes | No |
| 5. | Increase knowledge of art media | Yes | No | Yes | No |
| 6. | Create original artwork for your home | Yes | No | Yes | No |
| 7. | Learn how to compose pictures to draw or paint | Yes | No | Yes | No |
| 8. | Learn how to mix and use colors effectively | Yes | No | Yes | No |
| 9. | Learn to care for and use tools for creating art | Yes | No | Yes | No |
| 10. | Develop a greater appreciation for art | Yes | No | Yes | No |
| 11. | Make decisions more confidently now | Yes | No | Yes | No |
| 12. | Act more self-assured | Yes | No | Yes | No |
| 13. | Get better grades in school | Yes | No | Yes | No |
| 14. | Get along better with peers | Yes | No | Yes | No |
| 15. | Feel more comfortable being with other children | Yes | No | Yes | No |
| 16. | Develop a lasting interest in creating art | Yes | No | Yes | No |
| 17. | Take more pride in other things she or he produces | Yes | No | Yes | No |
| 18. | Behave more maturely at home | Yes | No | Yes | No |

19. What else happened **as a result of** our services that was good for your child?

_____

20. What else happened that was not good for your child, **as a result of** receiving our services?

_____

21. Other comments or suggestions: _____

_____

## ABOUT THE AUTHOR

Rita Young is an art educator and mother of two children. She currently resides in Fremont, California with her husband, Rex and two pomeranians. After graduating from San Francisco State University with a degree in drawing and painting in 1974, she practiced as a fine artist and freelance artist, and supported herself through a variety of other work in San Francisco. Her work is currently held in private collections nationally.

While her children were young, she was active in the PTA, serving on the board at unit, council and district levels as chairperson for The Reflections program. Rita also served as a Fine Arts Commissioner for the City of Cupertino from 1999-2004.

Rita has been an art educator since 1992 and founded The Marvegos® Fine Art School shortly thereafter. The philosophy and teaching method of The Marvegos® approach was designed for her children and developed from a desire to nurture the creative spirit Rita saw in her own children as well as the children of her friends. Rita understands the value of developing self-confidence to help children be the best they can be. Her son, Peter, is attending The School of The Art Institute of Chicago with plans to graduate this spring with a BFA in painting. Her daughter, Alexis, is an outsider painter and recently a theatre major at UCLA.

Rita is currently managing two studios in northern California, one in Saratoga and another in Fremont. She is busy with plans to expand The Marvegos® to other locales in northern California. Rita can be reached via her website, www.marvegos.com.